Scotland the Dreich

a celebration of all that is dreich

Luath Press Limited

EDINBURGH

www.luath.co.uk

D0434154

First published 2016
Reprinted 2017
Reprinted 2018
Reprinted 2019

ISBN: 978-1-910745-82-3

The paper used in this book is recyclable. It is made from
low chlorine pulps produced in a low energy, low
emission manner from renewable forests.

Printed and bound by CPI Antony Rowe, Chippenham

Typeset in 12 point Avenir Next

For the least dreich people in my life: Jenny, Eilidh, Joe and my dad, Norman.

dreich

/driːx/

adjective SCOTTISH

(especially of weather) dreary; bleak.
"a cold, dreich early April day"

Many years ago now, after a particularly comedy-fuelled night out during the Edinburgh Festival I bumped into a theatre reviewer friend of mine on the way home. I told him of my night of comedy, and he told me of his night of reviewing comic theatre. 'I'm sick of laughter. Time for some Joy Division', he said.

And so it is with dreich. We all love those long summer days of unbroken blue, and soft scented breezes, but what would they be without their counterpoint – days of cold, mist and a dampness that reaches the bones? I too love a perfect sunny day, but I must confess, I love a dreich one more.

There is a stillness to a dreich day that is matched by no other. It is not extreme weather in any sense. There are no violent rainstorms or shattering winds. Dreich days are not days of excess. They are quiet days, melancholy yet not depressing. They are a blank canvas on which to project future hopes. They are days to stay at home by the fireside, with a book and a dog asleep at your feet.

Dreich days are rarer than you would think. The perfect dreich day is a careful blend of light, water, mist and cloud. Get the mix wrong and your day may just be foggy, or rainy, or damp. Get the mix right and the perfect dreich day awaits. There is rain on dreich days, but never heavy or even moderately heavy rain. The rain is like a fine misting that, rather than falling, feels like it is suspended in the air.

Depending on the time of year, a dreich day can feel vastly different. In winter people scuttle through them, forced reluctantly outside to walk the dog in a cold and damp world.

In summer, for me at least, they can be welcome days when the cool tingle of moisture on the face is as invigorating as any cold shower. It is a word that is frustratingly hard to define, as the word itself is its own perfect description.

Strangely the word 'dreich' is almost always used to refer to daytime. I could probably count on one hand the amount of times I have heard someone lament that it was 'a dreich night out there'. This is an important aspect of a dreich day – its relationship with light. Some refer to these days as gloomy but to me this is too simplistic. It is more as if the light has gone missing, or is somehow paused. It is not as if dreich days are marked by darkness, rather that they are marked by an absence of light. They are funereal days; sombre, stately and respectful. They are far from 'days of mist and mellow fruitfulness' and are instead closer to the backdrop to every Gothic horror that ever tumbled from the laudanum-fuelled minds of early 19th century novelists.

I wanted to try and find out where the word dreich was most readily understood. I knew it was a Scottish word but was unsure if it was in general use beyond our borders. Therefore, in a hugely unscientific experiment, I turned to that font of all knowledge – Twitter – to find out. I set up a poll and let the Twittersphere do the rest.

The results showed that, as I suspected, almost all those living in Scotland were aware of the word while this figure fell sharply in relation to those outside Scotland. The north of England and Northern Ireland were the two areas outside Scotland to be most aware of the word.

Of course 'dreich' can refer to far more than the weather. The origins of the word are Germanic and correspond to the Old Norse word 'drjugr' meaning 'enduring, lasting, long-suffering'. This became the Old English 'dree' or 'dreigh' and the step to 'dreich' was simple. In the *Dictionary of the Scots Language* the

meteorological definition of 'dreich' comes far down the list behind older meanings such as weariness, monotonous, tediousness, tardy, lacking inspiration and, rather worryingly, slow to pay debts. These definitions have now essentially fallen out of use but were handy in choosing some of the photographs for the book as I was keen to avoid using fifty photos of overcast days. These different definitions gave me more scope to experiment with different subjects. I wanted to look at the idea of dreich as a state of mind, as well as a state of weather, and there is plenty of scope for this approach in Scotland. Therefore, I allowed myself some leeway in how I approached the photography for the book, which I hope has given a more varied and interesting appeal.

The actual photography itself was both straightforward and awkward. Despite Scotland's notorious weather it was often not the right weather in the specific part of the country I was in. To drive all day to Skye in the hope of some dreich weather is a risky business. Much studying of weather bulletins and forecasts occurred and

even then these are never 100 percent accurate. I would check with people in specific areas and if it was suitably dreich where they were I would jump into the car, but often when I arrived a couple of hours later the weather had changed. Therefore, much of the photography was done by always having a camera on me and always having a weather eye open…

I started the book in January 2016 and thought that over the next few months I would get the bulk of the photography done as I assumed this was when the weather would be most conducive. Not a bit of it however – it turns out that there is almost as high a chance of a perfect dreich day occurring in summer as in the winter. There were a good few days when the thought of braving the elements made the spirit sink, but like all things, once you take the plunge the rest is easy.

Days spent trudging round a country enveloped in a cloud of mist and moisture may not sound a pleasant experience to most, but these were days of solitude and calm with a silence that nudged at the soul and allowed the slowness of time with her soft muted colours and sounds to gently present themselves, whispering 'here we are, here we are'. Shadows fled under the diffuse light, and harsh edges and corners seem to soften and the world quietly paused.

Out on a high moor, with head slightly bowed and a wet and happy labrador ranging in circles around you it seemed the world was just waiting for something to happen – for the clouds to part and a glimpse of Eden to present itself. The clouds never parted and Eden was never revealed because this – the here, the now – was Eden enough. To be able to look out on

a desolate landscape, made by nature or by humans, and see only an untethered and unfettered beauty is a joy that is all the more sweet because of its fragility and lack of permanence.

No down – no up. No dark – no light. No tears – no laughter. No dreich – no sunlight. We need all of these contrasts. To live in the middle always strikes me as the worst of all possible worlds. A long-forgotten occurrence now, but the jittery TV which suddenly crackles into a perfect picture makes that perfect picture all the more welcome. We need the light. We need the dreich. We need all of it in a constant and joyous flux of change.

This book is a celebration of all that is dreich. To my mind the images in this book are uplifting and joyful. There is nothing

miserable about dreich. A sunny day has no more right to exist than a dreich one. Here then are fifty dreich images, accompanied by fifty equally dreich captions.

Enjoy the dreich.

Alan McCredie
Edinburgh
October 2016

Acknowledgements

Many thanks to Jenny Fraser, Daniel Gray,
Colin McCredie, John McMurtrie, Shonagh Price,
Iain Bain,Tony Kearney, Eilidh Cownie, Joe McCredie,
Billy Mack and Kim Allan without whom this book would
have been much harder to complete.

I Am A Very Long Way From Home

Like so many times before I make a wrong turn on the road and end up where I did not expect to be. Around a nondescript bend on a nondescript road the girl at the bus stop appears. Way down the road I can see a bus approaching. I do not have long but I have all the time I need. I take my photo and moments later she is gone.

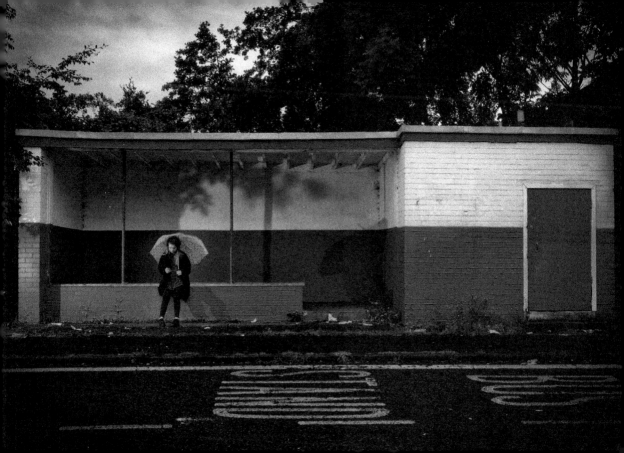

Shall We Play 'The Road'?

Around the time of the great California Gold Rush of 1849, the black gold of Scotland was being mined in larger and larger quantities. What hope for the future and what optimism saw a small mining village near Falkirk be christened California? The coal called to them and they came proudly along the California Road.

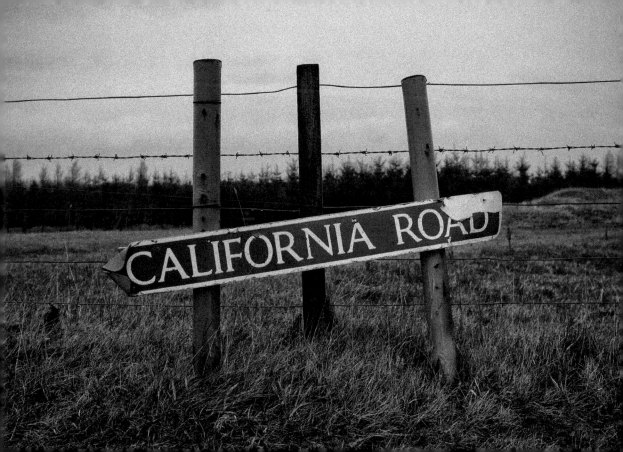

Life Without Buildings, Journeys Without Maps

On a cold, wet day, often it is only the dog walkers that venture out. Here in a housing development near Granton Harbour, unfinished and left to return to nature, they are the only people around to enjoy the stillness and the quiet. One day houses may yet be built and these empty places will be filled in.

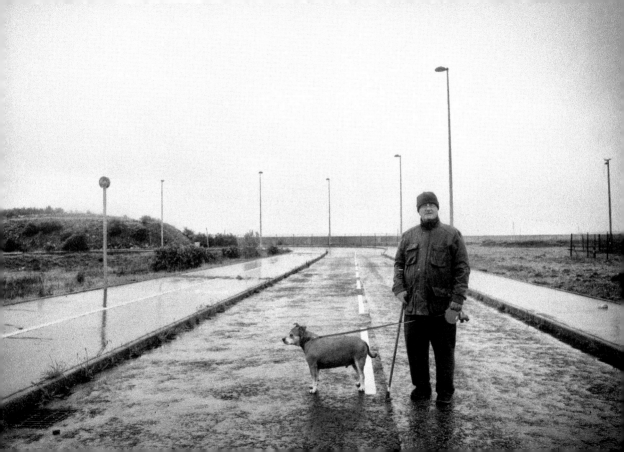

Days of Glory, Days of Wonder

Thousands of years from now will those from the far future discover our cast-off bottles of Buckfast and consider them an offering to some Berserker god that once held dominion over us? We leave our offerings for our future selves to find, like a Scottish Pokemon Go.

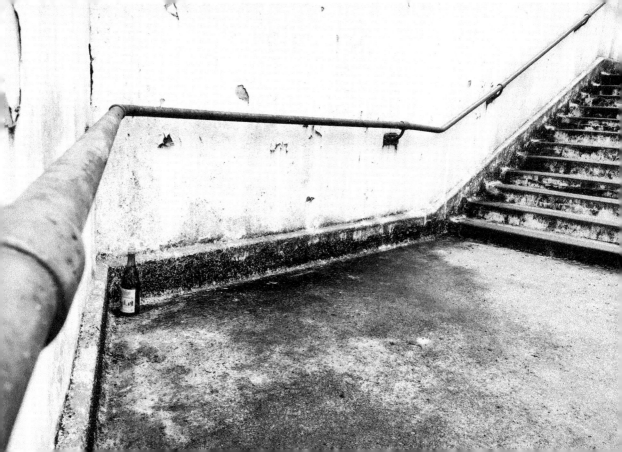

A Reassuringly Dull Sunday

Caravan park in winter. Deserted beaches and approaching rain. The sound of doors opening and closing and the rattle of old wind chimes as the weather worsens. A soft orange glow from inside the caravans, and the sound of a car creeping slowly by on potholed roads. These were the holidays of my childhood.

And I loved them.

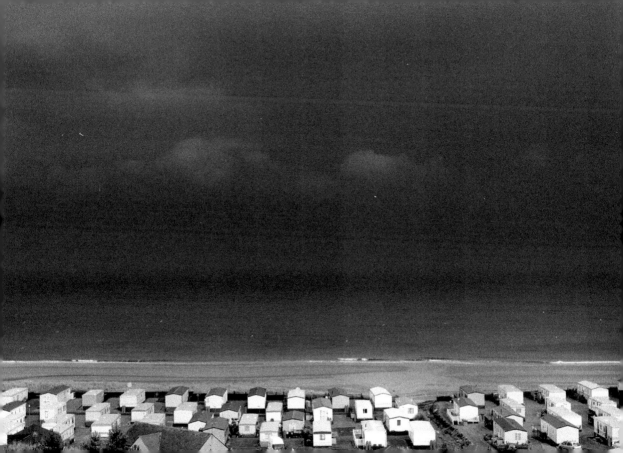

How To Bring A Blush To The Sky

No child ever minded a dreich day. Where we see cold and damp, they see only endless opportunities for fun. Puddles become great seas that only giants may cross. The gift of mud is everywhere. Round every corner something new. Something good.

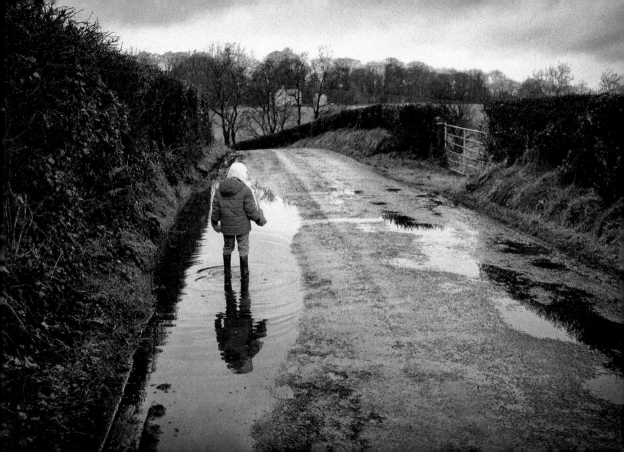

Vastly Increased Power, Verbally Defined Concepts

It changes from day to day. Sometimes from hour to hour. Living in Edinburgh I barely notice it any more, only reminded of its existence when watching tourists stop and stare. It is the backdrop to every arrival in the city and one of the last things visible on every departure. Today, shrouded in mist, it gently reminds us that it is from another time.

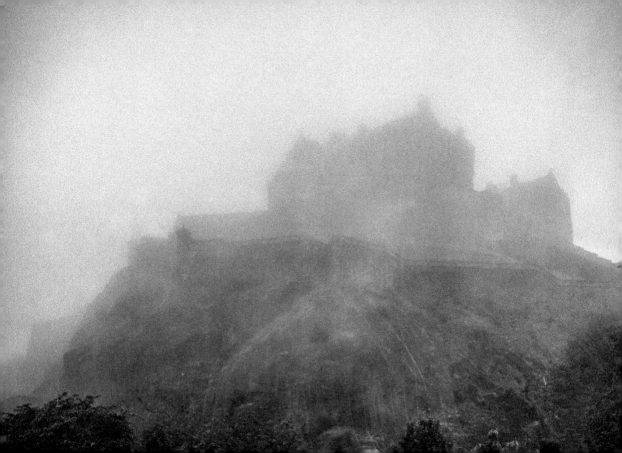

In Darkness We Can Only Imagine The Light

Night. Life behind windows. A cold mist falls. What words are spoken and what events unfold, mutely, as we watch? This is February in Perthshire and the land is in the grip of winter.

This is a house among the stars, where no stars shine.

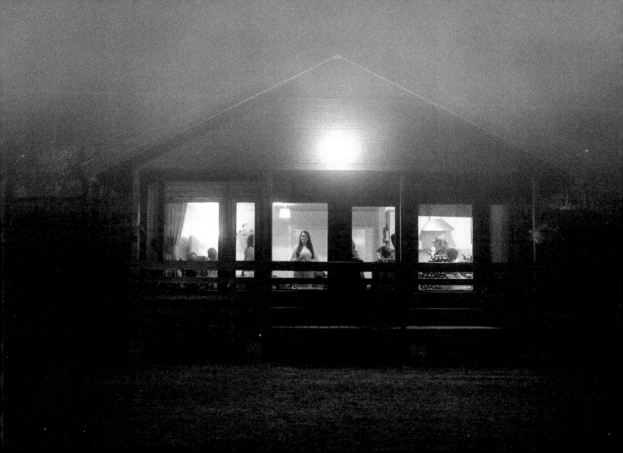

A Strictly Limited Interest

Early August in central Scotland is no guarantee of fine weather. A dreichness has swept in from the Hillfoots to the north and shrouded the town of Alloa on this the first day of the football season. Wet and cold the match is over. No misery in Alloa however; they have won 4–0.

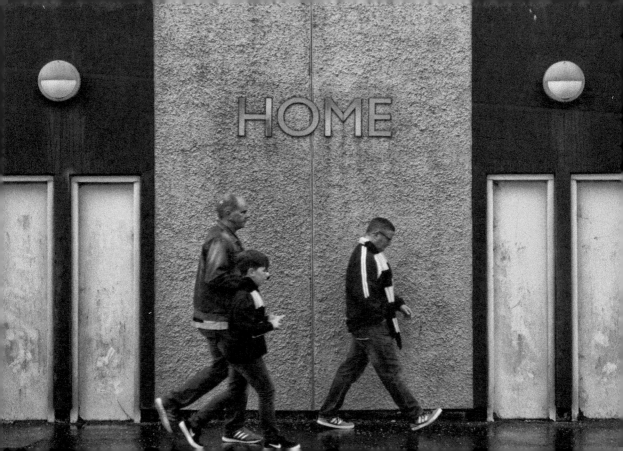

Finally Our Destination Comes Into View

High on a plateau in the undiscovered centre of central Scotland are towns and villages bypassed by motorways to the north, south, east and west. This was once coal country, shale oil country, but no more. A hard land, but one where a strange beauty is always close at hand.

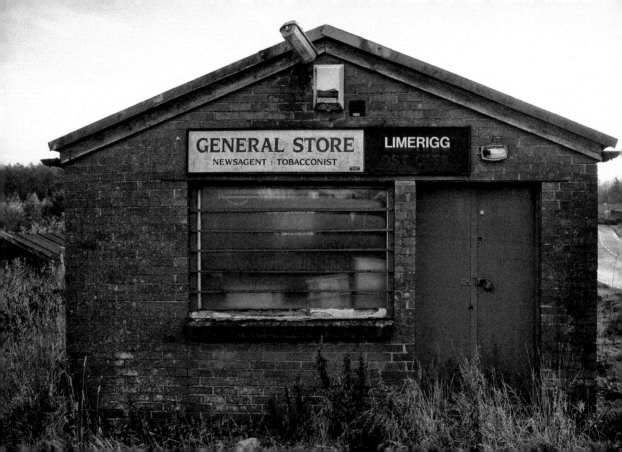

Newly Discovered Languages

Today there is a race to the top of Britain's highest mountain. It is late summer in the Highlands of Scotland and the weather is not joining in the carnival atmosphere.

We have canvas. We have beer. We will shame the weather.

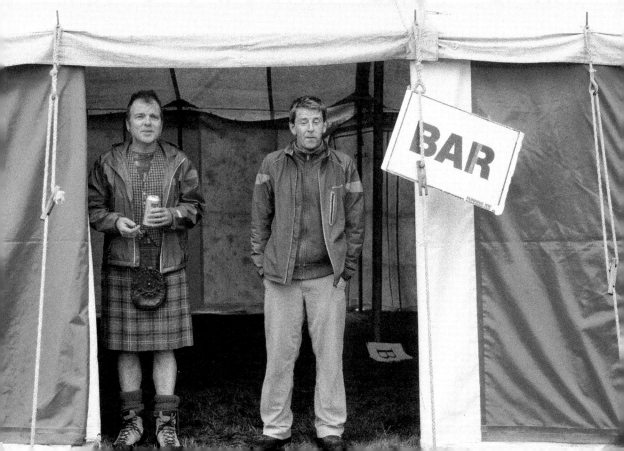

How Do We Get Home From Here?

Glencoe will not let me down. I drive in search of dreich weather, but Scotland is not being kind to me. Blue skies and puffy white clouds accompany me all the way from Edinburgh. Crianlarich goes by and I check the sky. A slight greyness? By Tyndrum and Bridge of Orchy my hopes are raised and by the time I reach Glencoe I have been rewarded, as anyone who visits here always will be. My reward is cloud and rain. What will yours be?

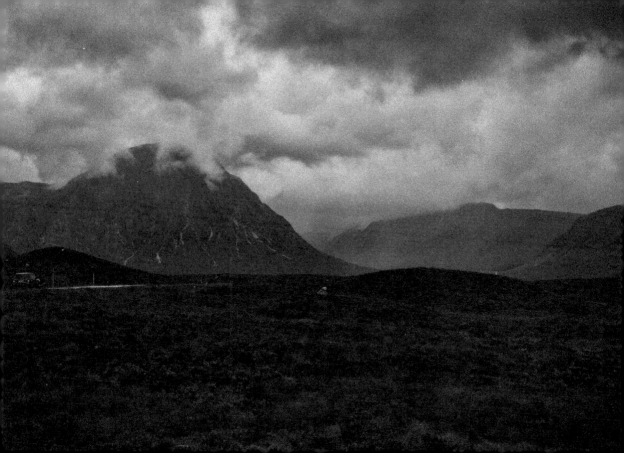

An Entirely Unfamiliar Country

Bus stops. I could have easily filled this book with images of bus stops on dreich days. Perhaps it is the way the people huddle for shelter that does it, or the eternal drabness of the structure that draws me to them on a wet day. They were a rich vein to mine.

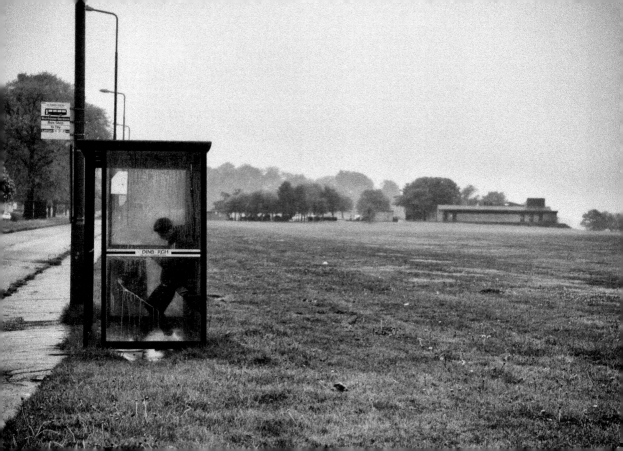

A Constantly Changing Background

A nameless industrial estate somewhere on the outskirts of Stirling.
Like so many times before, I am lost. Literally going round in circles
in this land that seems entirely constructed out of roundabouts. A
splash of colour in the gloom leads me on like a siren. A mobile
barber's. I take a photo and in return I pay for a haircut.
It's good. It's very good.

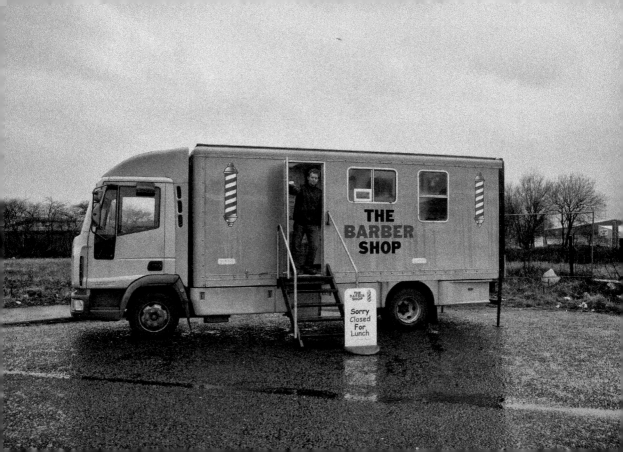

Sowing Seeds For A Spring We Will Never See

I mistake it for the nuclear power station that I know is nearby
and I worry about the smoke. I check my map again and realise
my mistake – a cement works. It came into view suddenly,
around a bend bordered by hawthorn and cow parsley. A shaft
of light catches the smoke as it merges with the cloud and I
think it is the most beautiful thing I have ever seen. It isn't, but
in that moment it feels like it.

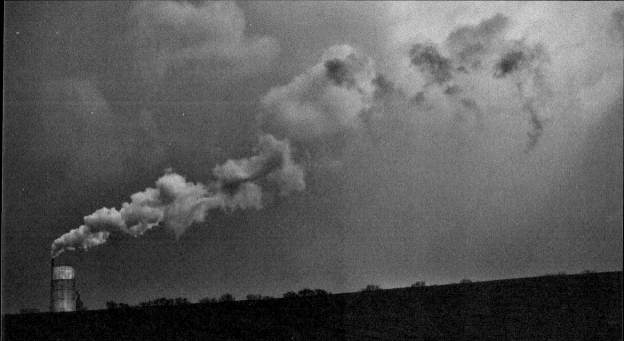

We Built It But They Did Not Come

A Bright Future! Work For All!

These and other lies were doing the rounds when this housing estate was being laid out in New Cumnock. Roads were built, power lines laid, sewage and water pipes buried in the earth. Even an occasional house was finished. Yet when the lampposts were finally lit they illuminated nothing. The coalmine had withered and the people never came.

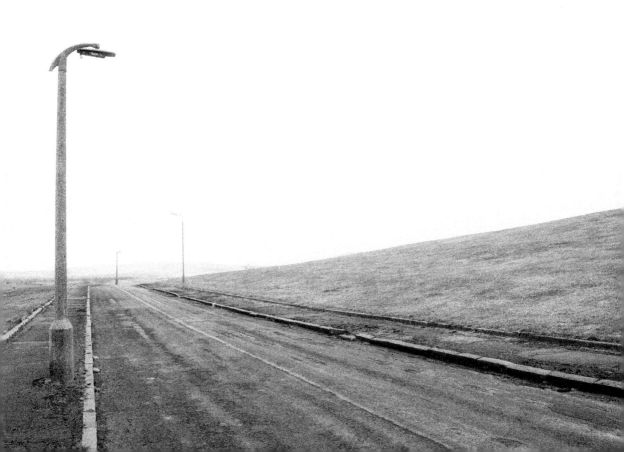

We Stand Across The Travelled Path Like A Wall

I have made it to the top. The Bealach na Bà. The Pass of the Cattle that snakes alarmingly up and over before dropping to Applecross on the far side of the mountain. I am driving a forty-year-old VW Camper and it barely made the climb. If I had met anything coming the other way, down the mountain, I would never have got going again. Even though the effort was all mechanical and not really mine I feel the view is still somehow a reward for my imagined efforts.

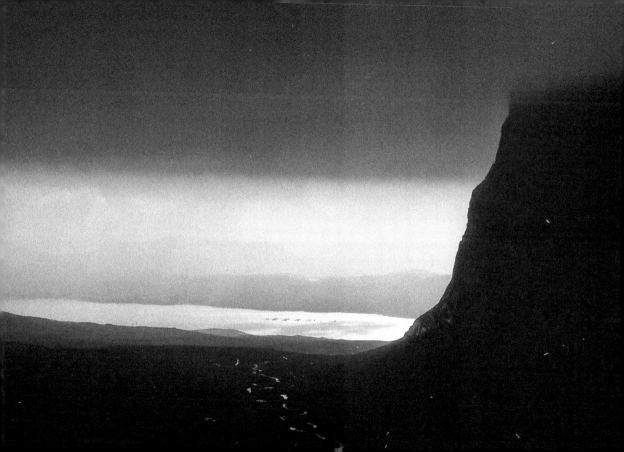

Into The Light From Behind The Veil

I had come here for the starlings. I wanted to see their murmurations as they swept and soared over the border town of Gretna. They may have swept and they may have soared but the low cloud meant I could not see them do it. I left the gloom and headed towards the light. I would salvage something from the night yet.

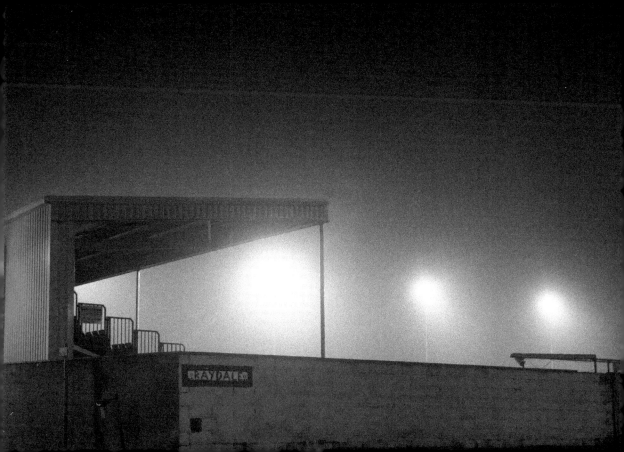

A Totally Unexpected Result

A million arrivals, a million departures. They walk over pavements that look like walls to ships that will take some towards home and take others away from it. Does each goodbye have a mirror-image welcome on the other side?

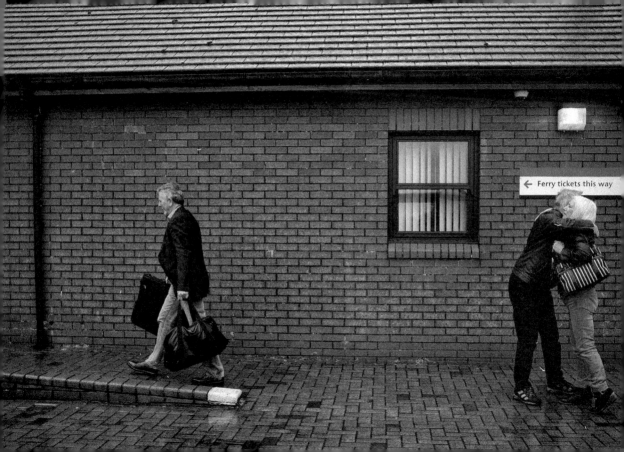

Ferry tickets this way

Natural Life By Artificial Light

I wait for my fish to fry and wonder what they are doing in San Francisco. Fresh OJ for breakfast? The working day has begun in Chicago and in Tokyo the neon is lit and the evening is in full swing. Sydney has somehow lost ten minutes.

It is 3pm in Pitlochry.

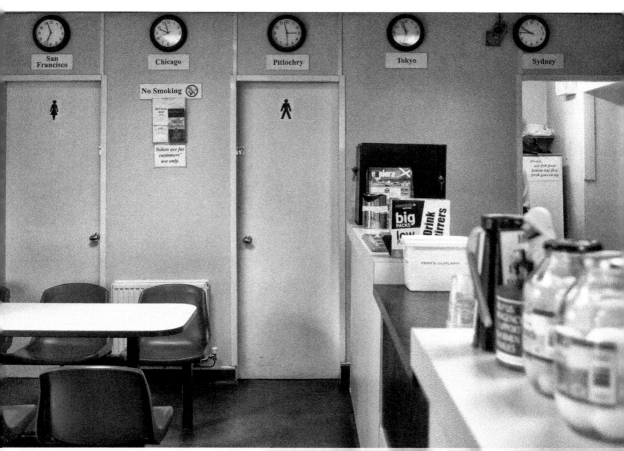

Vibrations May Cause Drinks To Fall

It is summer in Kelvingrove Park in Glasgow and it is as dreich as a November day. They are penned into designated smoking areas and their rainwear is sponsored by beer. Pink for boys, yellow for girls. Drag deeply on those cigarettes as the band will be on soon!

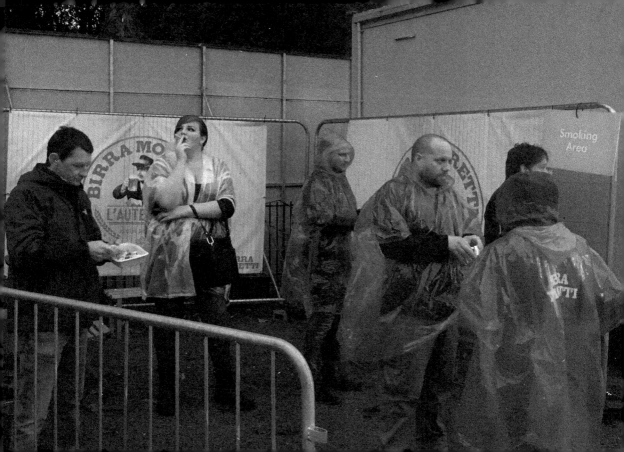

Eyes Widen In Surprise

Bright colours will show us the way in the quickening gloom. It is a dreich day on Arran and the weekenders have had enough. Two days of rain has dampened their spirits and it is time to leave. Not all are downhearted though – I came here for rain and I received it. In abundance.

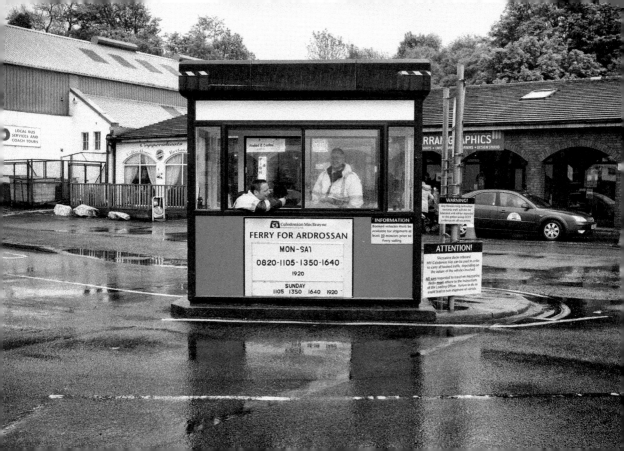

We Are Not Happy Campers

The Castle That Sold A Million Tins Of Shortbread is quiet today. Cloaked in its natural environment it looks far more like the castle it was than the image it has become. Eilean Donan is a magical place. It is haunting in the gloom and it is the way I like to see it. The sun will shine again and the shortbread tins will sell again but this, against a dark background, is how a castle should look.

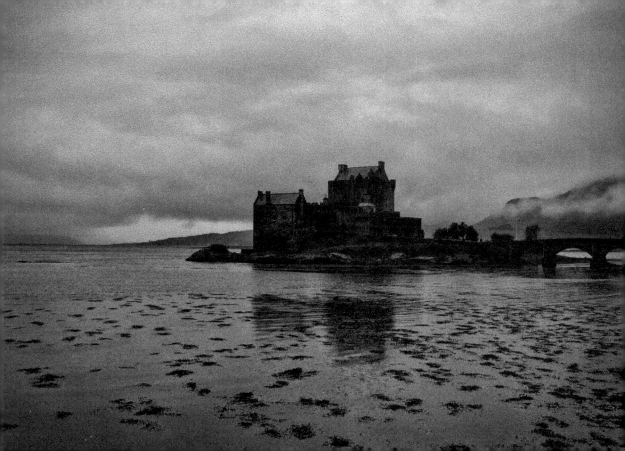

A Fundamentally Different Approach

They came here to see the majesty of the mountains. I overhear
them as I take my photographs. They talk of seeing the Cuillin of
Skye before they head home. I fear they may be disappointed.
A dark cloud has descended over the island and the Cuillin are
allowing only the briefest glimpses of themselves. Once again I
feel like the anti-tourist. I want everything to look almost the polar
opposite of everyone else. And I usually get my wish.

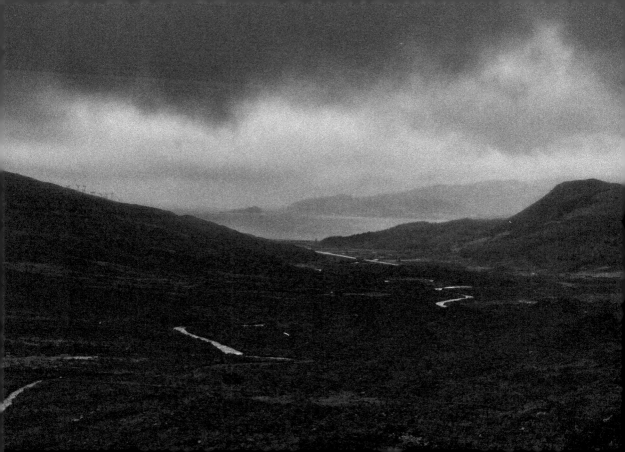

A New Way To Look At Old Problems

I have witnessed many a footballing funeral at this place. In years gone by it would be a funeral more often than not for my own hometown team. Lately the tide has turned and it is often a funeral for the opposition. All things pass, however, so a Funeral Tea will await me once again.

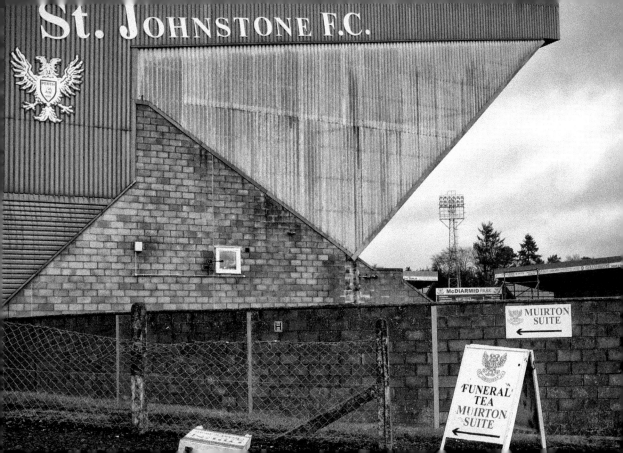

This Is Where We Stopped, This Is Where We Fell.

White paint on a slate roof. 'PUB', 'HOTEL', 'TEAS'. Reminiscent of old postcards, vibrantly coloured in a way they are not anymore. And disappearing fast. Occasionally you will see them, but the pub below the roof is gone. The hotel shut down. The Tea Shop closed.

Happily, here the roof did not lie.

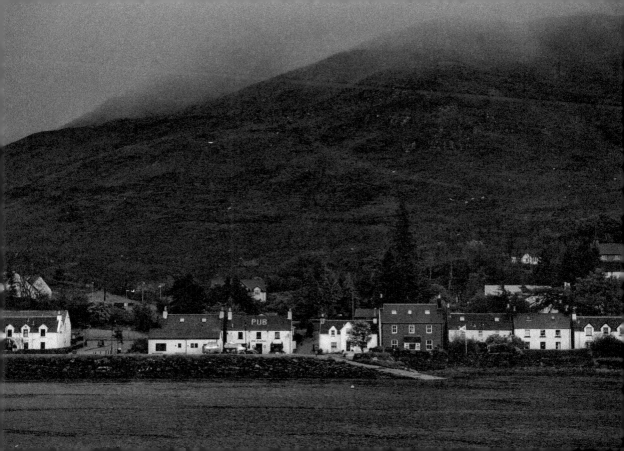

The Fog Came Down And The Mist Was Our Ally

A debatable land, mired in violence, intrigue, battle and uncertainty. The borderlands of Scotland and England have hidden many a secret in their time. When the mist rolls down from the Cheviots the border becomes what it truly is: amorphous, unknowable and utterly insignificant.

The land has no knowledge of the lines we draw upon it.

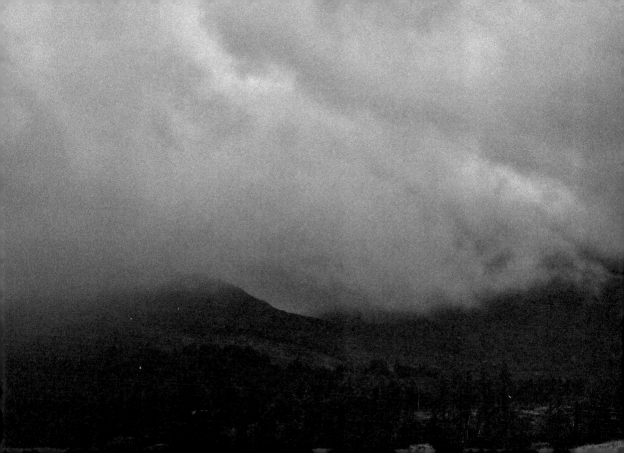

Raise Your Arms To The Absence Of The Light!

Images appear from nowhere. I turn a corner high above the sea at Crail and before me a tableau. What is happening here? I catch them for an instant and freeze them for ever. I move on, looking back every so often but nothing changes. I hear the dog bark but I have turned another corner and they are out of sight.

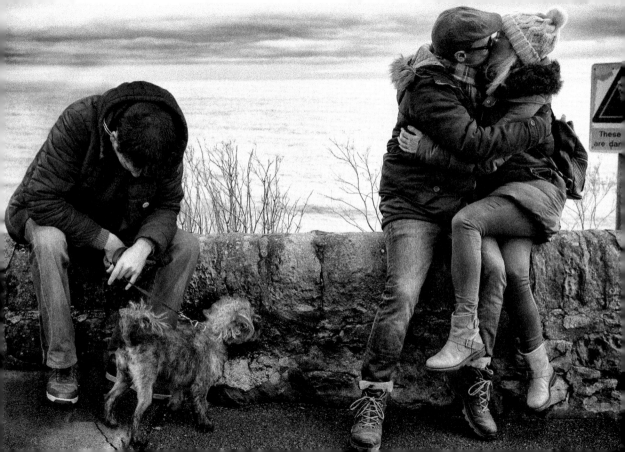

Our Sea A Line Between Two Harbours

The German Romantic painter Caspar David Friedrich would often paint silhouetted figures against brooding backgrounds. In making this book I often found myself unwittingly doing the same. On a dreich day I would be drawn to the sea and there, without fail, I would find people standing and staring out into the mist. There is nothing to see but still they looked.

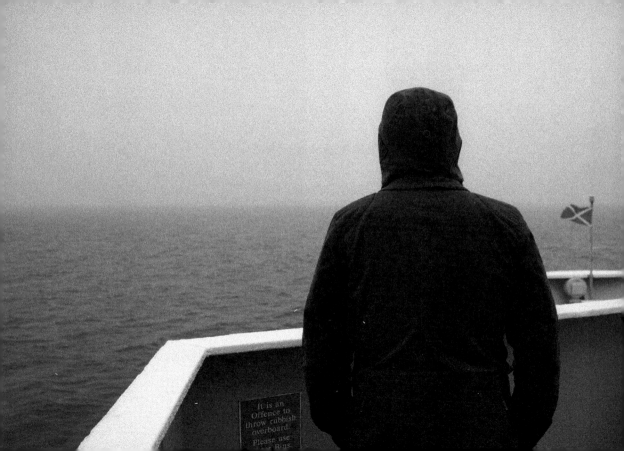

A Slight Roughening

Give me the run-down over the new and shiny. To wander around a new town, here, Brora, is a joy. To leave the centre behind and head off down side-streets is always my first action. Hand-painted signs and shops that are not identical are the last dying rays of civilisation.

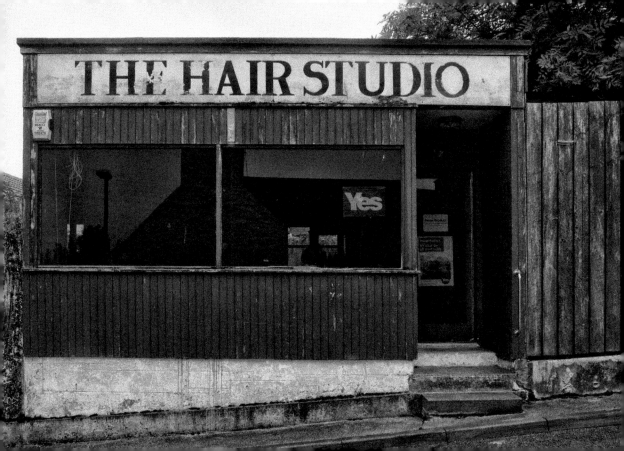

We Are Hewn Into Rudimentary Human Shapes

Another bus stop. Another homage to Caspar David Friedrich. Perhaps it is because these are places where people are invariably still that sees me hovering around bus stops in Fife towns on cold winter days. Perhaps there is a kindred feeling as we are both waiting. For buses, for the perfect shot. Waiting.

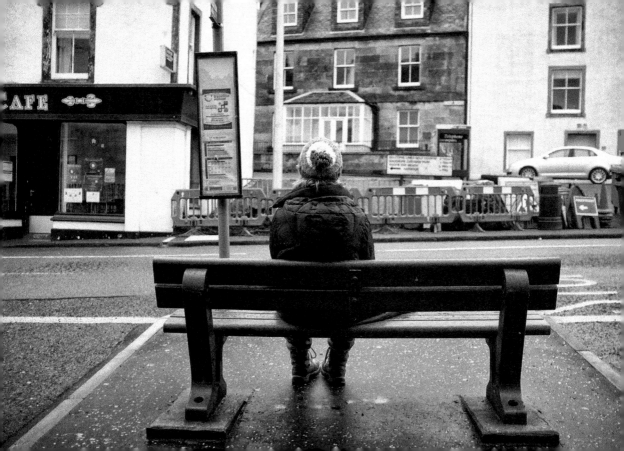

To The Sky Above And The Earth Below

South Uist loves a roadside shrine. If the weather were fine (which I am delighted it is not) could I imagine myself in Italy where the roadside shrine also abounds? Probably not, but then South Uist has a unique beauty that no place on earth can match.
Better beaches than Italy too.

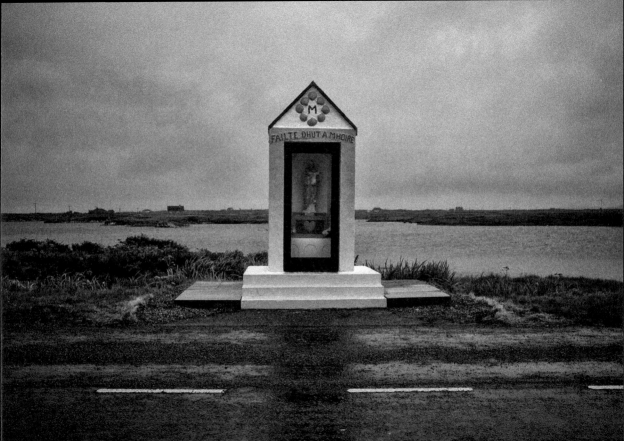

An Unusual Way To Start A Fire

Progress is good. Progress is essential. Sometimes things get left behind though. Deep in the countryside, a dark night with the air damp and chill is suddenly illuminated by an old telephone box. It seems to say, 'We are not alone! Keep going! You are almost there!'

Progress is good, but things get left behind.

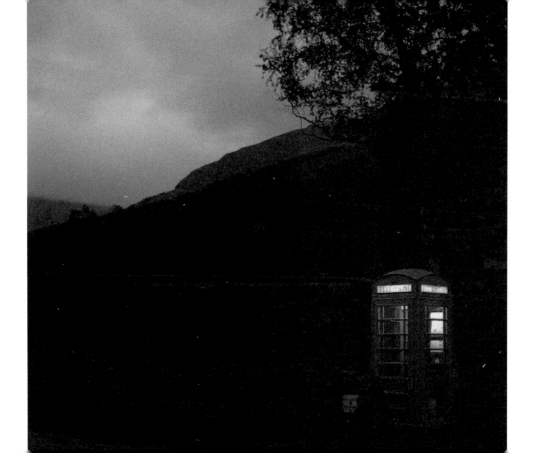

Still Life In Mobile Homes

The caravan. It seems to dwell in the dreich like no other structure can. It is its natural habitat. There seems to me a perfect symbiosis between a caravan and a day of creeping cold and mist. The smell of bottled gas and windows obscured by condensation are as much part of a dreich day as gloom and rain.

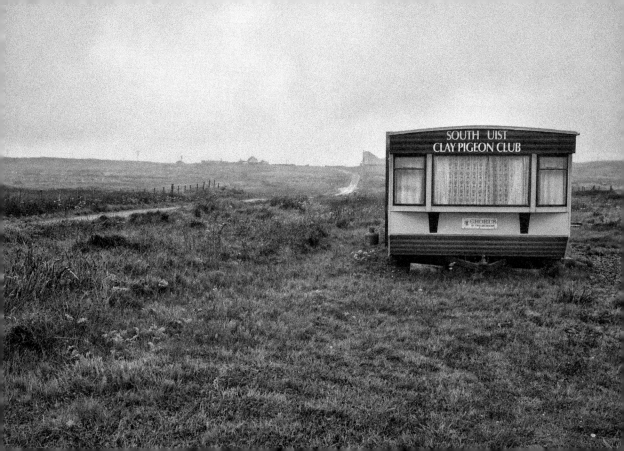

A New Approach For Living

'Is THAT the Cuillin?'

Another stop on Skye, an island in the cloud, and still the mountains remain a vague, brooding presence hovering at the edge of our vision. Tantalisingly out of sight, yet their existence and solidity can be felt even at this distance. While the others strain to look into the distance, I am caught up in the foreground by a bridge as perfect as any I have seen.

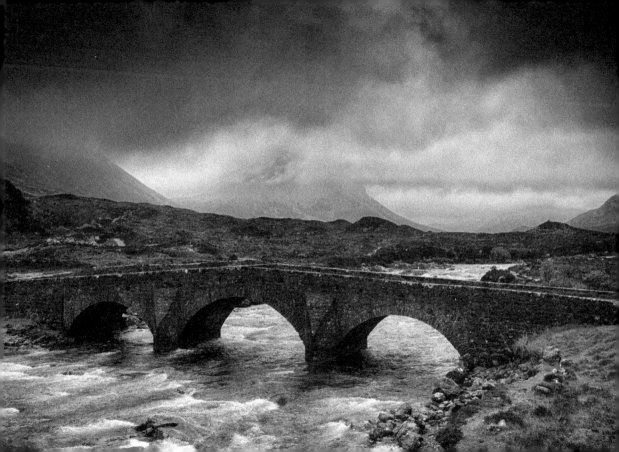

We Must Model The Kind Of Response We Get From Others

Eriskay in the Hebrides, and a football pitch clinging to the land before the vast Atlantic that encroaches upon it. Manoeuvred somehow between ancient rocks, it sits proudly with sheep for spectators. FIFA has decided this is one of the eight best places to watch football on the planet.

They are correct.

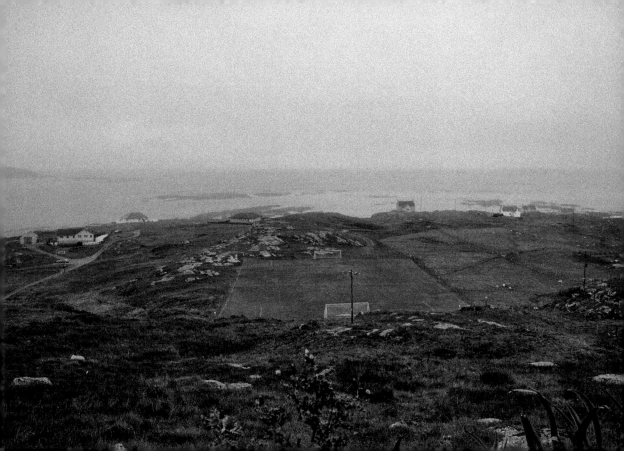

The Shattered Winds Of Winter Will Follow Us Home

It is bitterly cold. I have been driving for hours and have finally reached Ardfern on the Craignish Peninsula. The hotel bar is warm and happily noisy but stoically I venture out into the dreich evening with my camera. This is, after all, why I am here. I wander for a bit but the light fades quickly and I turn for home. I fight my way through a small wood and find the one shot I can use. One is all I need. I carry on back to the hotel and by the time I arrive it is fully dark.

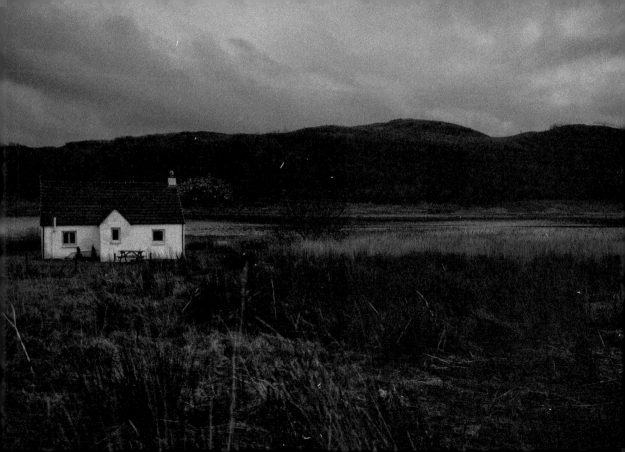

Where The Railroad Meets The Sea

In the distance I can hear the unmistakable sound of a train clattering over the tracks. I think of the title for the photograph before I have taken the photograph. The train, the sea and the gulls above all provide a soundtrack for this as yet untaken image.

Later, back at the hotel, I look at maps and find there is no railway anywhere near where I was. A ghost train, or the sound carried in on the wind. I don't really mind as I like the title too much to change it.

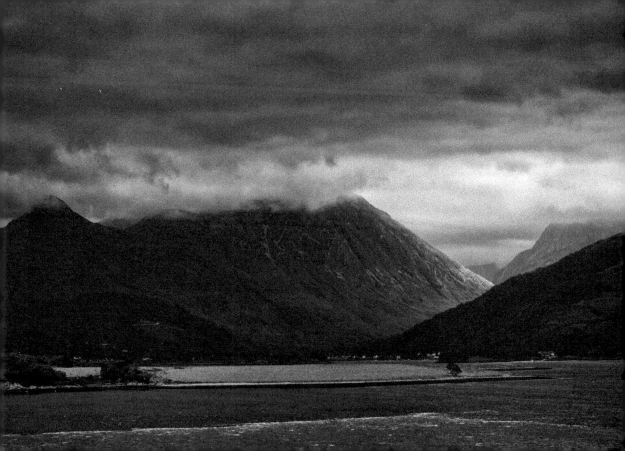

A Landscape Of Our Memory

I have travelled all over Scotland in the last few years taking photographs for various projects, and in all that time I keep coming back to the one image that was taken closest to home. Leith Links, shrouded in mist as the light fades, is still one of my favourite photos. Nothing is happening in the photo, and this more than anything is why I like it so much.

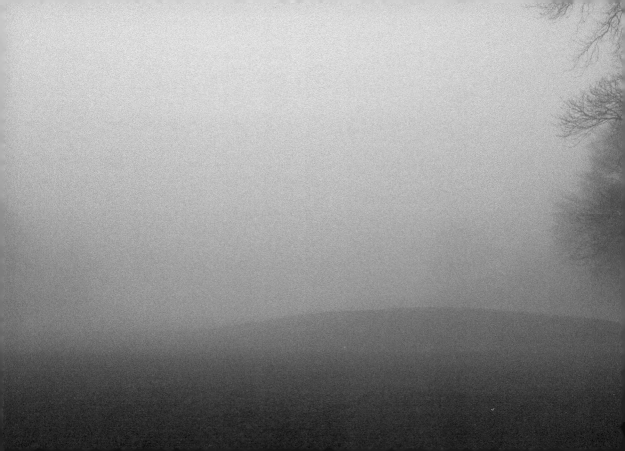

Across This Or Any Other Bridge

When I began this book, I knew what I wanted to avoid was lots of people walking in the rain holding umbrellas. I have failed this test twice, but sometimes photographs that are just too good to miss present themselves. Rules are only interesting once they are broken.

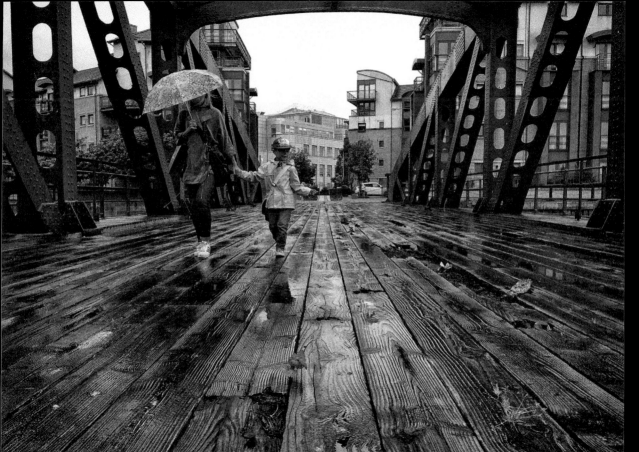

Once, These Fading Beacons Lit The Night

Down dark and quiet streets, enclosed by high tenements on either side of the road, the corner fish & chip shop was once king. We were guided to them by their light, often the only illumination on long and empty roads. Many have gone now but those that remain still have the power to entice the weary traveller.

Not this one sadly. Its lights no longer shine.

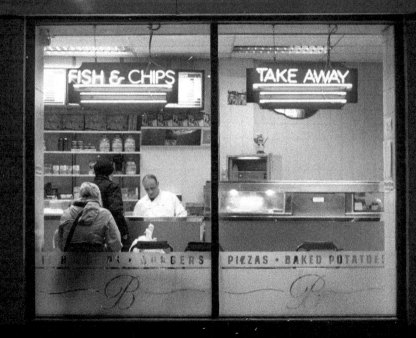

Is This What We Call Our Home?

Under an old railway bridge I stop to wonder. Who placed this sofa here? Did they carry it or – as I suspect – throw it from the bridge? Was it brought for a purpose or just dumped? Did a weary shopper rest on it before carrying on and leaving their stolen trolley behind? There are beer cans in the trolley. As I walk off I find myself hoping that they had a nice time.

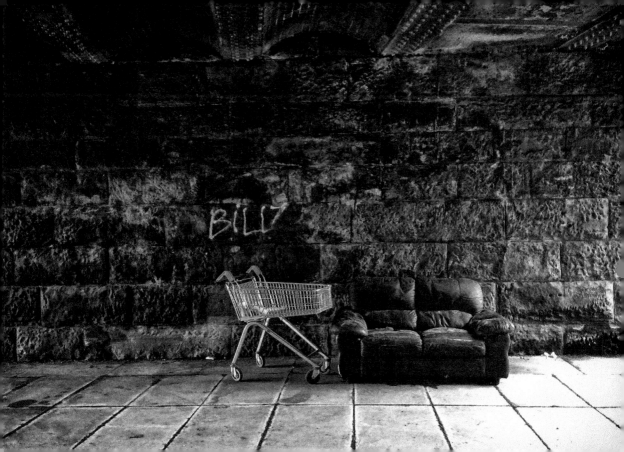

The Dear Grey Place Of Yesterday

'What a day it is!'

My new friends are not happy with the weather. I pretend to be in agreement with them but obviously I am delighted. I am in Denny, in the urban heart of Scotland, and the weather is particularly to my liking. The women are bemused when I ask to take their photograph, but kindly agree – and an otherwise lifeless photo is given a touch of warmth on a cold day.

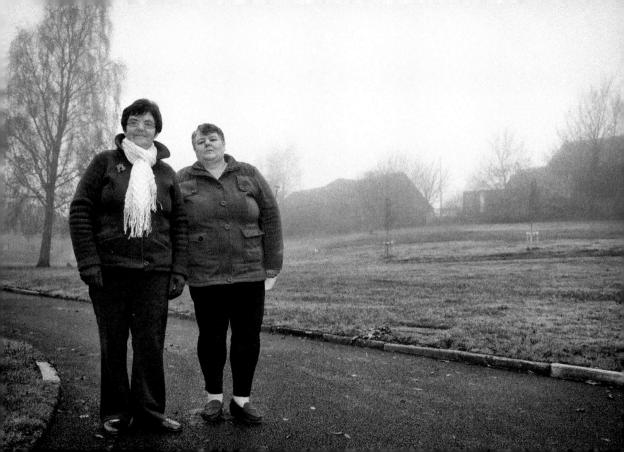

To Stare At Seas Long Gone

My friend Caspar David Friedrich has influenced me for the final time. Again I am near the sea and again people stop and stare at it, and I in my turn stop and stare at them. What is out there? What are they thinking about?

I would love to ask but do not have the courage.

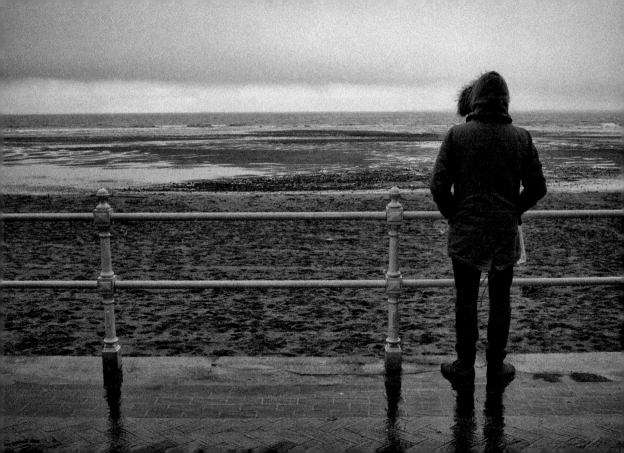

A Constantly Recurring Theme

I once went to a football match in Edinburgh where the sun shone, it was warm, and I had a perfect view over the half-way line of the entire pitch. I did not like it one bit. Where was the gloom? Where was the cold that slowly took over your entire being from the feet up? Hands that are too frozen to open the match programme are an essential part of football.

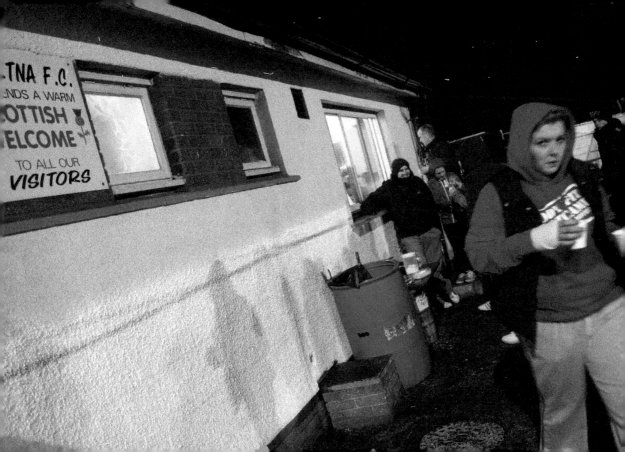

An Accidental Change Of Direction

We had not meant to come this way. It was warm and sunny
when we set out but a sea mist rolled in from the German
Ocean and suddenly the world had changed. We headed
for sanctuary and found it in a coastal pub. Then the runners
appeared. One by one, out of the mist. I do not know where
they came from or where they ended up. I took another drink
and did not think of them again.

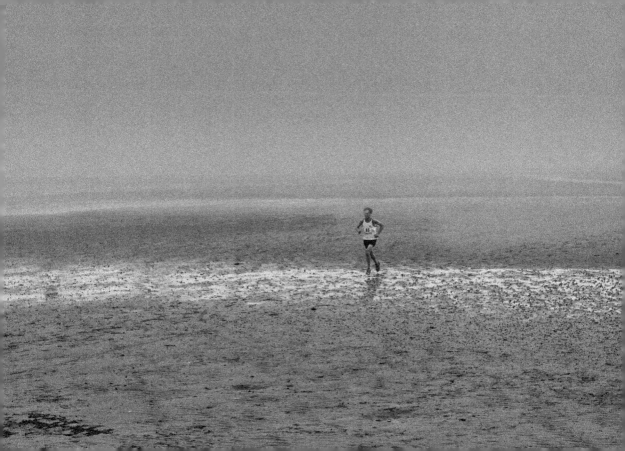

Remembering the Corner of Montparnasse and Raspail

Beauty is everywhere and in the least expected places. Standing in front of world famous European buildings will often see me taking a weary photograph because I think I should. Put me on a street in Lumphinnans in Fife on an overcast day and I will be there for hours taking photographs because I want to.

How did I become like this?

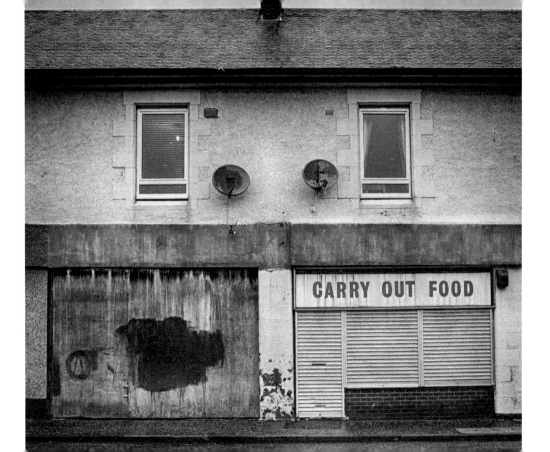

A Pale Country Ahead Of Us, A Pale Country Behind

It dominates the skyline over the M8 motorway a few miles east of Glasgow. It sits darkly brooding on a ridge looking for all the world like a backdrop from *Night Of The Hunter*. The Kirk o' Shotts has always fascinated me. It looks from a distance like the ultimate expression of Calvinism. Stark and severe and joyless before the sky. Closer in though it seems to soften. It is a fine old church and inside it is an exercise in elegant simplicity.

Today they are on the lookout for a new minister – and every motorist on the motorway is aware of it.

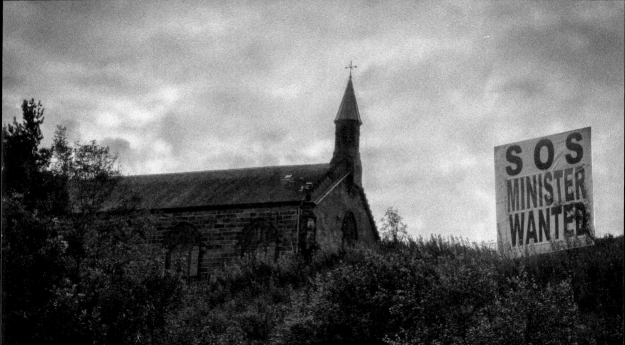

Where All Who Wander Are Not Lost

They came over the hill and out of the rain like dream-figures. Wet through, but tall and defiant. Such defiance. They paused for only a moment and then carried on walking. They walked and walked and walked. I lost sight of them eventually but knew they were still there. Still walking.

This Time They Did Not Spare Our Blushes

What fun we once had here! Pennies dropped into slots and teetering coins wavered and then toppled with a noise that could have been the soundtrack to our youth. Mechanical arms grabbed at, and then endlessly dropped, stuffed Yoda toys. Fruit machines greedily took and grudgingly gave. The smell of fried food and spun sugar. The music that was the same as any played at any fair at any time over the last forty years. This was funland.

It is flats now.

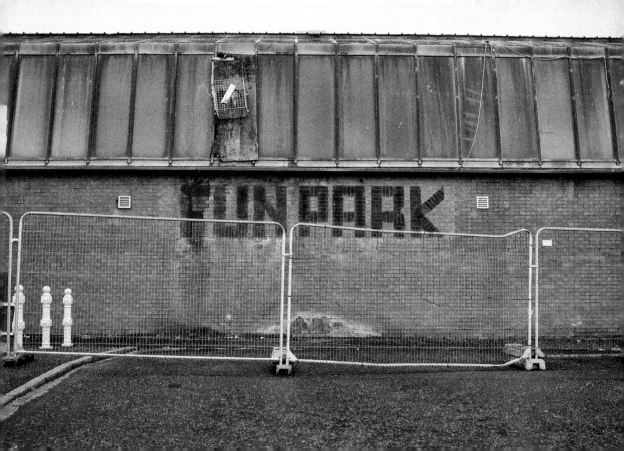

Strangely, as a professional photographer I take almost no interest in the technical aspects of photography, but I know that many do. For those that are interested I used a Nikon D800 and a Nikon D700 camera for the majority of photographs in this book. Both are thankfully waterproof… There are a few photographs taken on my lovely and loved Fuji X100 camera which makes taking photographs even more of a joy than it already is. As I subscribe to the ethos that 'the world's best camera is the one you have in your pocket' there are also a couple taken on an iPhone.

All the images are digital although I wish I had had the time and inclination to have shot it all on film. Next time.

As for exposure times, aperture, ISO etc? I have absolutely no idea, and even less interest. All the images in this book are available for viewing and purchase by visiting my website – www.alanmc.co.uk – and following the 'Scotland the Dreich' link.

Gilmerton, Edinburgh

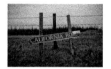

California Road, California, near Falkirk

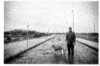

Granton Harbour, Edinburgh

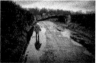

Govan, Glasgow

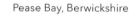

Pease Bay, Berwickshire

Near Grantown-on-Spey, Speyside

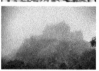

Edinburgh Castle

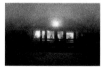

Logierait, Perthshire

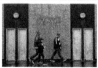

Recreation Park, Alloa

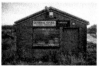

Limerigg, near Falkirk

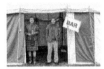 Claggan Park, Fort William

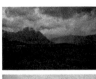 Looking north to Glencoe

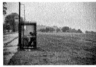 Muirhouse, Edinburgh

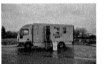 Industrial estate, Stirling

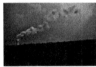 Cement works, Dunbar

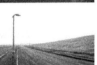 Unfinished housing estate,
New Cumnock, Ayrshire

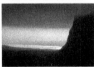 View from the Bealach na Bà,
near Applecross

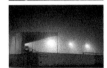 Raydale, Gretna

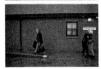 Brodick Ferry Terminal,
Isle of Arran

 Fish and chip shop,
Pitlochry, Perthshire

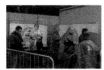 Kelvingrove Park, Glasgow

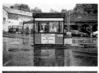 Brodick, Isle of Arran

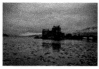 Eilean Donan Castle

 Toward Raasay, Isle of Skye

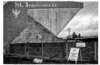 McDiarmid Park, Perth

 Dornie, Ross-shire

 Near Town Yetholm, Roxburghshire

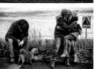 Crail, East Neuk of Fife

Ardrossan, Ayrshire

Brora, Sutherland

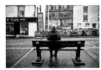

Crail, East Neuk of Fife

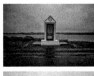

Roadside Shrine, South Uist

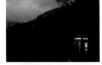

Kingshouse, near Balquhidder

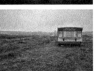

South Uist, Hebrides

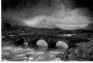

The bridge at Sligachan,
Isle of Skye

Football pitch,
Eriskay, Hebrides

Ardfern, Argyll and Bute

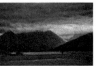

Looking east to Glencoe

Leith Links, Leith, Edinburgh

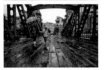

The Shore, Leith, Edinburgh

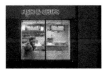

Once of Broughton,
Edinburgh

Queen's Park, Glasgow

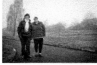

Macaras Park, Denny,
Stirlingshire

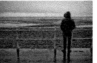

Promenade, Portobello beach

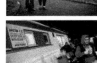

Raydale Park, Gretna

Elie beach, Elie,
East Neuk of Fife

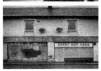

Lumphinnans, near
Cowdenbeath, Fife

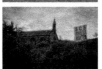

Kirk o' Shotts, Shotts

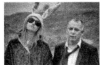

On Sherrifmuir, near Stirling

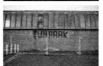

Amusement arcade, Portobello

This is Scotland

Daniel Gray and Alan McCredie
ISBN: 978-1-910021-5-90 PBK £9.99

This is Scotland is Daniel Gray's fifth book. His first solo work, *Homage to Caledonia: Scotland and the Spanish Civil War* (Luath), was turned into a two-part television documentary for STV. His second, *Stramash: Tackling Scotland's Towns and Teams* (Luath), received widespread acclaim, with *The Herald* calling it 'A brilliant way to rediscover Scotland', which made getting lost in Cumbernauld while researching the book worthwhile. An exiled Yorkshireman, he lives in Leith.

Alan McCredie is the photographer behind *100 Weeks of Scotland*, a celebrated online project documenting all aspects of Scottish life in the two years before the independence referendum. McCredie has been a freelance photographer for a decade, working with most major agencies in Scotland and beyond. He has specialised in theatre and television but is perhaps best known for his documentary and travel photography. A member of the Document Britain photo collective, he is a Perthshire man lost to Leith.

100 Weeks of Scotland: A Portrait of a Nation on the Verge

Alan McCredie
ISBN: 978-1-910021-60-6 PBK £9.99

100 Weeks of Scotland is a revealing journey into the heart and soul of Scotland in the 100 weeks that led up to the independence referendum in September 2014.

From the signing of the Edinburgh Agreement through to the referendum and its immediate aftermath, this book charts a country in the grip of political debate. *100 Weeks of Scotland* is not simply a political book. It brings together stunning photography and stimulating commentary to capture a country in transition.

It examines Scotland in all its forms from its stunning landscapes to its urban sprawl to, most notably of all, its people as they live their lives in the run-up to the most significant democratic event in their country's history. It is a portrait of a nation on the verge of the unknown.

Luath Press Limited
committed to publishing well written books worth reading

LUATH PRESS takes its name from Robert Burns, whose little collie Luath (Gael., swift or nimble) tripped up Jean Armour at a wedding and gave him the chance to speak to the woman who was to be his wife and the abiding love of his life. Burns called one of the 'Twa Dogs' Luath after Cuchullin's hunting dog in *Ossian's Fingal*.

Luath Press was established in 1981 in the heart of Burns country, and is now based a few steps up the road from Burns' first lodgings on Edinburgh's Royal Mile. Luath offers you distinctive writing with a hint of unexpected pleasures.

Most bookshops in the UK, the US, Canada, Australia, New Zealand and parts of Europe, either carry our books in stock or can order them for you. To order direct from us, please send a £sterling cheque, postal order, international money order or your credit card details (number, address of cardholder and expiry date) to us at the address below. Please add post and packing as follows: UK – £1.00 per delivery address; overseas surface mail – £2.50 per delivery address; overseas airmail – £3.50 for the first book to each delivery address, plus £1.00 for each additional book by airmail to the same address. If your order is a gift, we will happily enclose your card or message at no extra charge.

543/2 Castlehill
The Royal Mile
Edinburgh EH1 2ND
Scotland
Telephone: +44 (0)131 225 4326 (24 hours)
Email: sales@luath. co.uk
Website: www. luath.co.uk